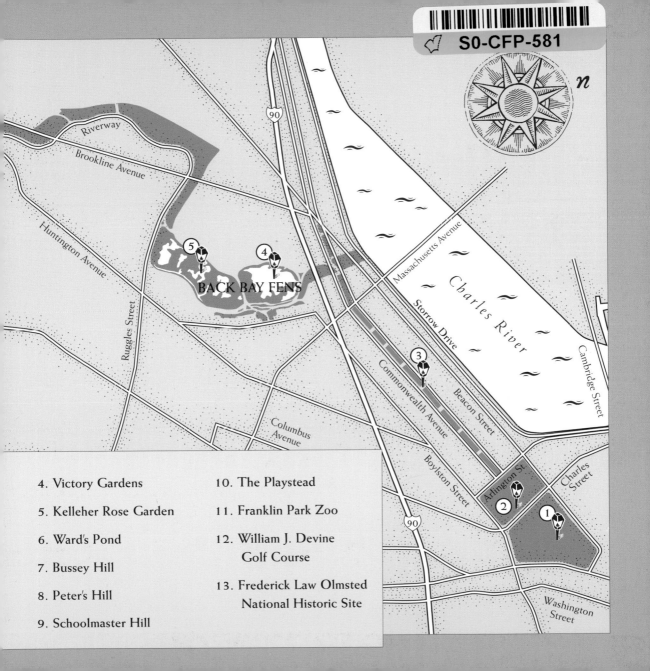

n

Riverway

Brookline Avenue

Huntington Avenue

Ruggles Street

90

⑤ ④

BACK BAY FENS

Massachusetts Avenue

Charles River

Storrow Drive

Beacon Street

Cambridge Street

Columbus Avenue

③

Commonwealth Avenue

Boylston Street

Arlington St

Charles Street

90

② ①

Washington Street

Library of Congress Cataloging-in-Publication Data

Tobyne, Dan.
 The Emerald Necklace / photographs by Dan Tobyne ; text by Perry McIntosh.
 p. cm.
 ISBN-13: 978-1-933212-23-4 (alk. paper)
 ISBN-10: 1-933212-23-3 (alk. paper)
 1. Parks--Massachusetts--Boston--History. 2. Parks--Massachusetts--Boston--Pictorial works. 3. Olmsted Frederick Law, 1822-1903. I. McIntosh, Perry. II. Title.
 SB482.M42.B67 2007
 712'.50974461--dc22

 2006100054

ISBN-13: 978-1-933212-23-4 (alk. paper)
ISBN-10: 1-933212-23-3 (alk. paper)

Cover and interior design by Peter Blaiwas, Vern Associates, Inc.
Printed in South Korea.

Published by Commonwealth Editions
an imprint of Memoirs Unlimited, Inc.
266 Cabot Street, Beverly, Massachusetts 01915
www.commonwealtheditions.com

Images from this book are available from www.laylaenterprises.com

The New England Landmarks Series
Cape Cod National Seashore, photographs by Andrew Borsari
Walden Pond, photographs by Bonnie McGrath
Revolutionary Sites of Greater Boston, photographs by Ulrike Welsch
Providence, photographs by Richard Benjamin
Newport, photographs by Alexander Nesbitt
Boston Harbor Islands, photographs by Sherman Morss, Jr.
Portsmouth, photographs by Nancy Grace Horton
Boston's Emerald Necklace, photographs by Dan Tobyne

Boston's
Emerald Necklace

PHOTOGRAPHS BY DAN TOBYNE

Text by Perry McIntosh

COMMONWEALTH EDITIONS
Beverly, Massachusetts

*B*oston today boasts many beautiful parks, but for over two hundred years the only open space in the city was Boston Common. In 1634 Boston households paid six shillings each to set aside this spot for grazing cattle, training militias, and hanging heretics and other criminals. Bostonians only began using the Common as a public park when the city added walkways in 1675. In 1728, trees were planted along Tremont Street, but the gallows remained until 1817 and cows continued to graze until 1830.

During this early period Boston was almost an island, consisting of the present-day North End and Beacon Hill neighborhoods, which were connected to the mainland by a narrow spit of land along what is now Washington Street in the South End. Just west of the Common was a tidal mudflat known as the Back Bay; construction of Mill Dam in 1814 had cut off some 430 acres of salt marsh from the Charles River's cleansing tides, converting the area into a stinking sewer. By 1837, the city began filling this nuisance, twenty-four acres of which were

transformed into Boston Public Garden, the country's first public botanical garden, now home to the famous pedal-powered Swan Boats and statues honoring the immortal children's story *Make Way for Ducklings*.

By 1870, most of the Back Bay had been filled and the former mudflat was on its way to becoming the fashionable brownstone neighborhood we see today. The wide, tree-lined Commonwealth Avenue Mall became a popular place for a stroll or carriage ride.

As the growing city gobbled up farmlands to the west and south (Roxbury being one town that was merged into Boston, Dorchester another), Bostonians longed for more parks and open space. In 1878 the Boston Park Commission turned to Frederick Law Olmsted for a solution. Olmsted, already famous for transforming a huge chunk of Manhattan into New York's Central Park, spent three years studying potential sites, then offered a plan that would allow Bostonians to, in effect, "find the city put far behind them."

IT IS PRACTICALLY CERTAIN THAT THE BOSTON OF TODAY IS
the mere nucleus of the Boston that is to be. It is practically
certain that it is to extend over many miles of country now
thoroughly rural in character.

— Frederick Law Olmsted, 1870

(*overleaf*) The Great Seal of the City of Boston,
Public Garden entrance

Soldiers and Sailors Memorial,
Boston Common

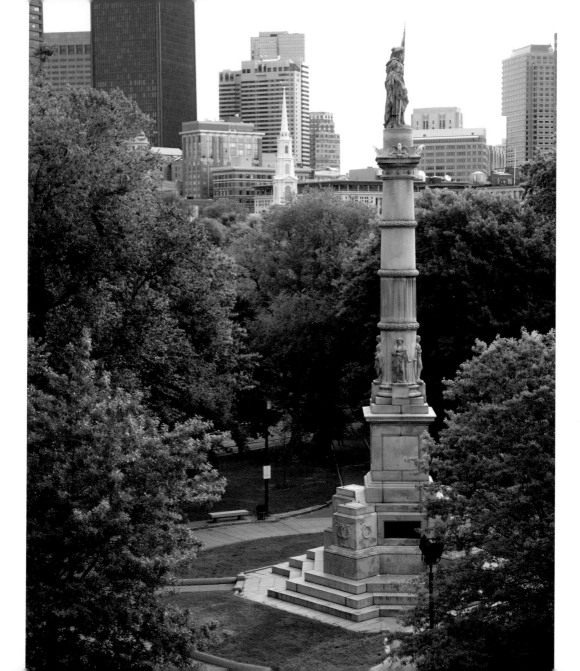

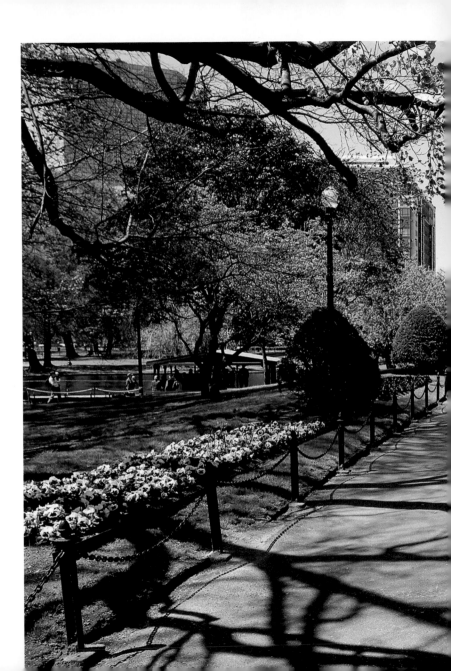

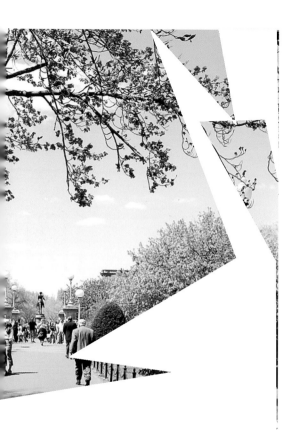

MY LIFE NOT AVAILETH ME IN comparison to the liberty of the truth.

—Mary Dyer, Quaker,
 hanged as a heretic
 on Boston Common,
 June 1, 1660

Public Garden in spring

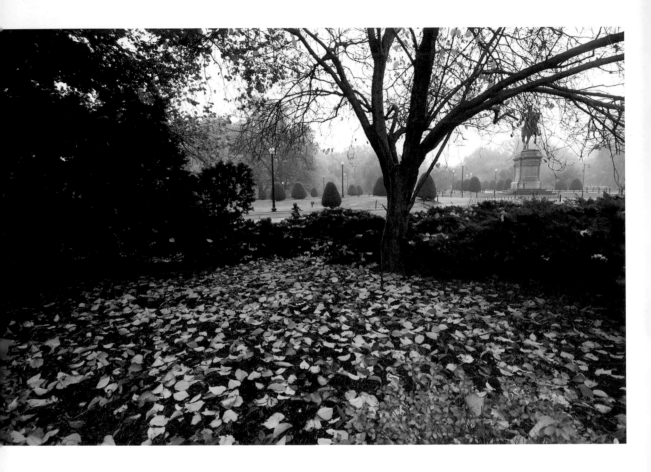

George Washington statue, Thomas Ball, 1869

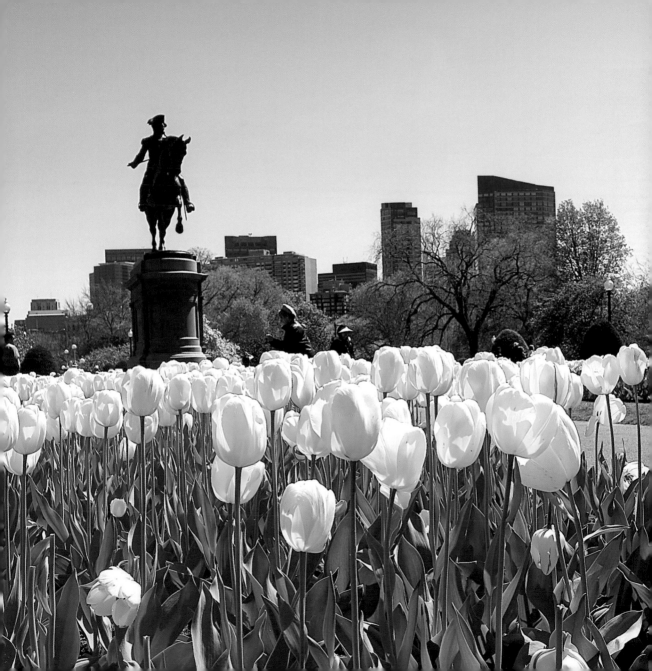

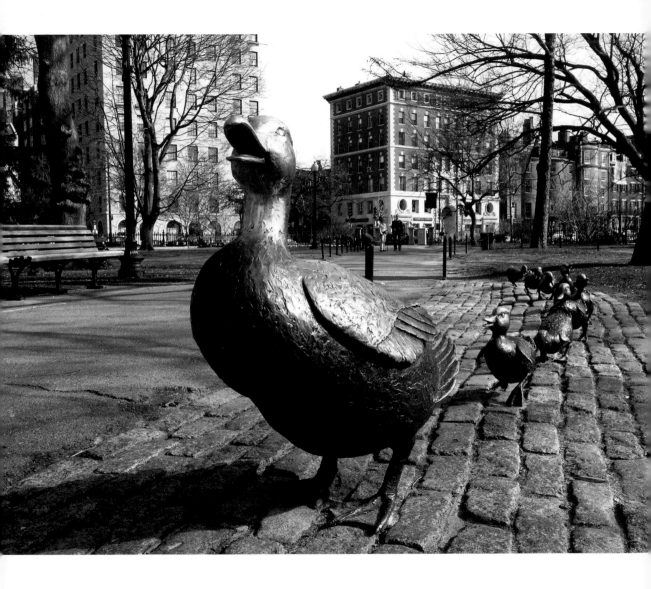

ONE DAY THE DUCKLINGS HATCHED OUT.
First came Jack, then Kack, and then Lack,
then Mack and Nack and Ouack and Pack
and Quack. Mr. and Mrs. Mallard were
bursting with pride. It was a great
responsibility taking care of so many
ducklings, and it kept them very busy.

—Robert McCloskey,
 Make Way for Ducklings, 1941

TO THE BODY AND MIND
which have been cramped by
noxious work or company, nature
is medicinal and restores their
tone. The tradesman, the
attorney comes out of the din
and craft of the street, and sees
the sky and the woods, and is a
man again. In their eternal calm,
he finds himself.

—Ralph Waldo Emerson,
from "Nature," 1836

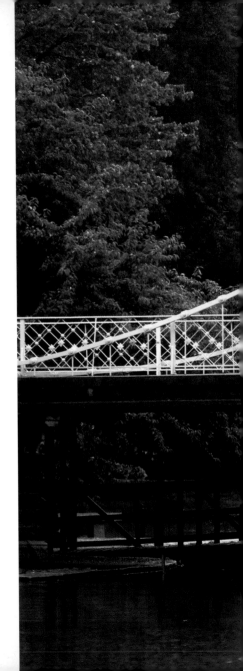

A pair of swans near the Public Garden's
small suspension bridge

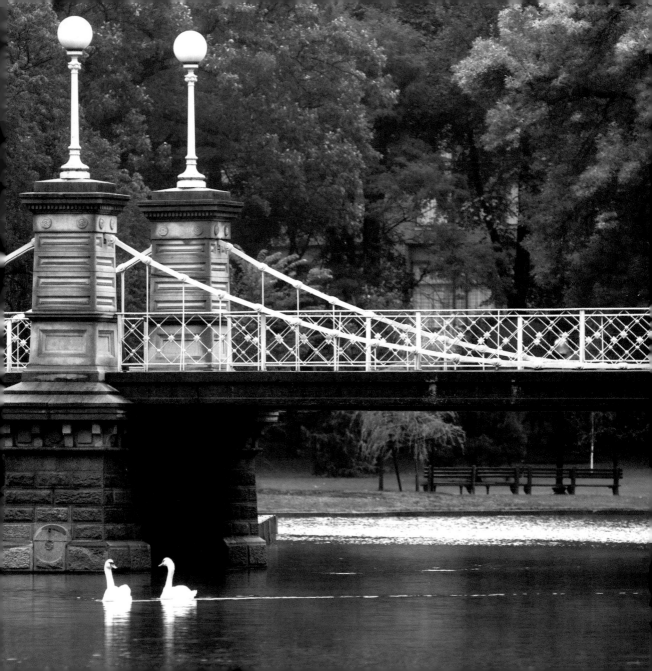

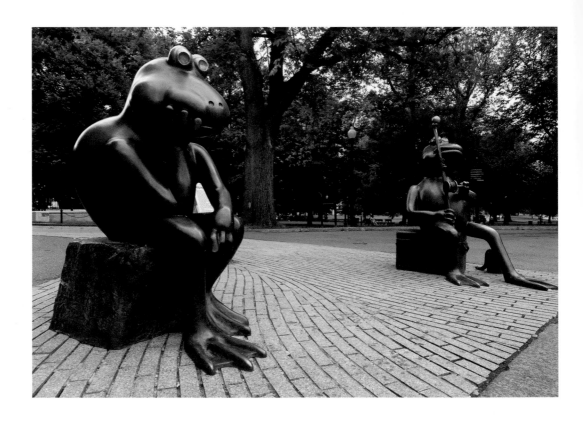

Statues at Frog Pond, Boston Common,
watch waders in summer and skaters in winter

Haffenreffer Walk, Public Garden

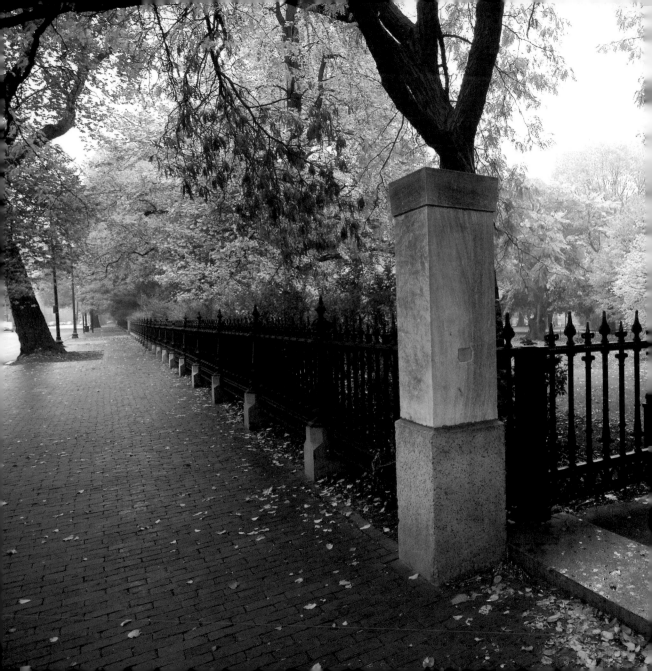

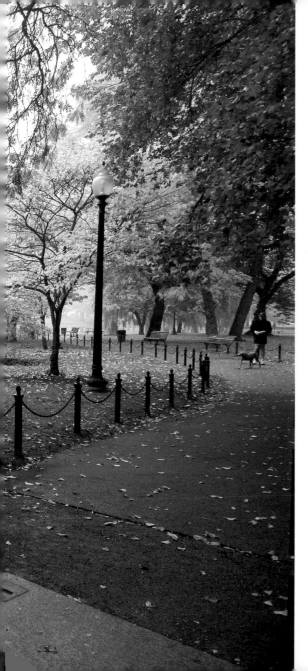

IS IT DOUBTFUL THAT IT DOES men good to come together in this way in pure air and under the light of heaven, or that it must have an influence directly counteractive to that of the ordinary, hard, hustling working hours of town life?

—Frederick Law Olmsted,
*Public Parks and the
Enlargement of Towns*

Arlington Street Gate, Public Garden

Frederick Law Olmsted (1822–1903), acclaimed today as the father of landscape architecture, might have ended up a dry goods clerk, a mariner, a farmer, a journalist, or a publisher. While exploring these diverse careers, Olmsted glimpsed the positive influence of parks on city dwellers when he visited Liverpool's newly opened Birkenhead Park in 1850. Here he witnessed people from all walks of life enjoying greenery and fresh air, seemingly far removed from the din of city streets. Olmsted's journals from the trip were filled with quotations from Emerson, Wordsworth, Carlyle, and Mrs. Gaskell, writers who extol the virtues and value of nature.

Olmsted's career took an abrupt turn in 1857: he applied for and received the position of Superintendent of New York City's Central Park, then 770 acres of scrub and reservoirs slated for development as a downtown park. The plan he created in collaboration with Calvert Vaux was chosen over 32 others, and he spent the better part of two decades implementing it. The outcome, Central Park, met with universal acclaim.

All over the country, cities were expanding, cutting off their inhabitants from the pleasures of open space. Olmsted believed that overcrowding made people nervous and wary of one another and increased their susceptibility to disease. Parks, in his view, were "civilizing forces" that offered calming recreation and democratizing forces that bought people of all economic classes and neighborhoods together.

Olmsted and other civic leaders shared a vision for Boston—a linked chain of parks that he referred to as a green ribbon. Integrated with the city, the parks would be approached by tree-lined avenues and, in Olmsted's words, offer "the harassed city dweller daily relief from crowded streets, buildings, and the spiritual aggravations of commerce and the densely populated neighborhoods."

It took almost 20 years to finish the six parks known today as the "Emerald Necklace." Olmsted moved his family and office to Brookline in 1883 to be close to the project. His home, "Fairsted," housed the landscape architecture firm he built with his sons. It is now maintained by the National Park Service (and expected to reopen in late 2008). Covering more than 1,000 acres of land and stretching over five miles, the Emerald Necklace stands as one of the crowning achievements of Olmsted's career and continues to help Bostonians escape the noise and stresses of urban living.

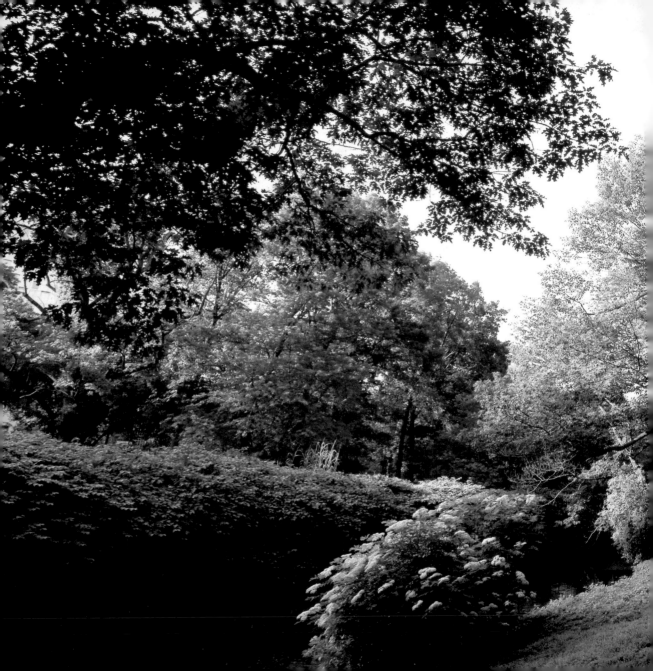

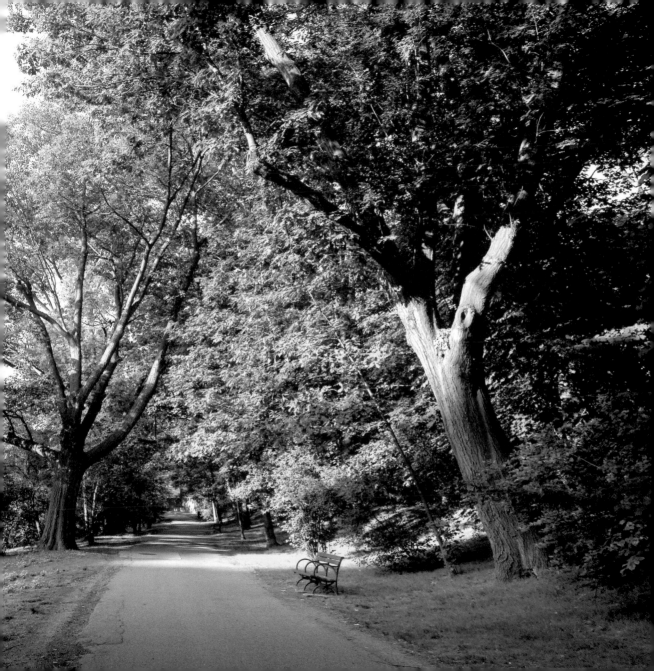

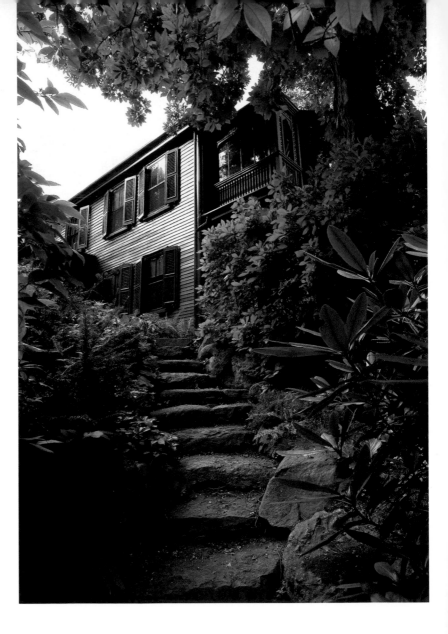

(*overleaf*) Early on a summer
morning, along the Muddy River

Frederick Law Olmsted's home,
Fairsted, in Brookline

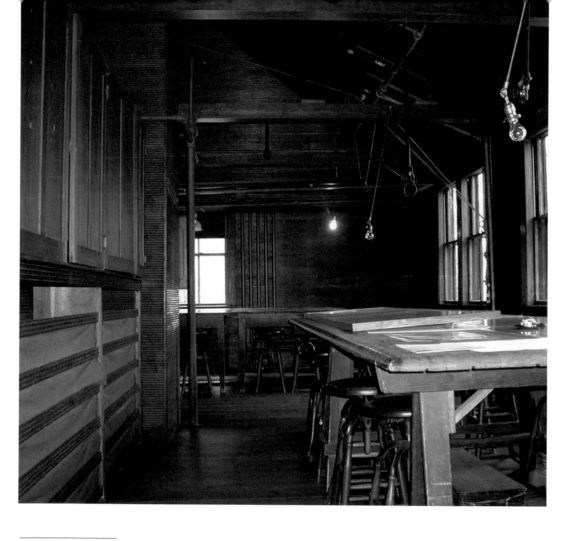

Olmsted's workshop

PARKWAYS... SHOULD BE SO PLANNED AND
constructed as never to be noisy and seldom
crowded, and so also that the straightforward
movement of pleasure carriages need never
be obstructed, unless at absolutely necessary
crossings, by slow-going heavy vehicles used
for commercial purposes. . . . they should be
made interesting by a process of planting and
decoration, so that in necessarily passing
through them, whether in going to or from the
park, or to and from business, some substantial
recreative advantage may be incidentally gained.

—Frederick Law Olmsted, 1870

Statue honoring sailor and historian Samuel Eliot Morison,
Commonwealth Avenue Mall

(*overleaf*) Agassiz Bridge, the Fenway

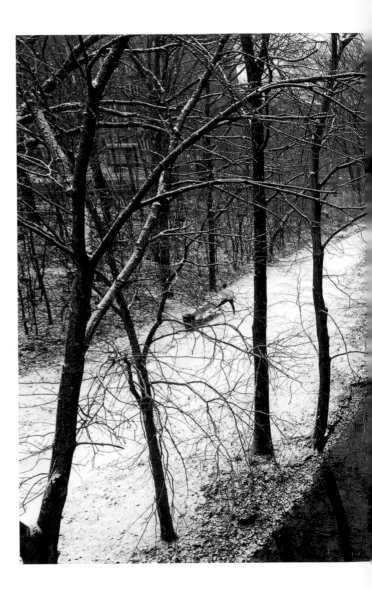

Muddy River in winter

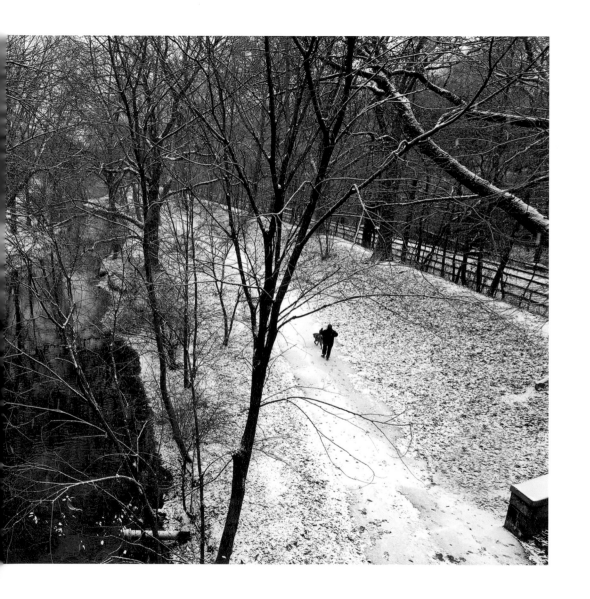

Olmsted planned the new parks of the Emerald Necklace to connect with Boston's existing parks, Boston Common, the Public Garden, and Commonwealth Avenue Mall. His 1878 master design was carried out piecemeal as land for the parks became available, but over time it was nearly completed in full. As a result, today's Bostonians can travel for miles in green spaces that seem far removed from the city.

Olmsted's first project, the Back Bay Fens, addressed a long-standing problem. Several mill dams on the Charles and Muddy Rivers had cut the estuaries off from the ocean's cleansing tides. To the disgust of people in the fashionable new Commonwealth Avenue neighborhood, the marshes had become open sewers and the nearby tidal basin was a breeding ground for mosquitoes. Making a virtue of necessity, the Parks Commission filled the basin and converted the space into a new park. Olmsted proposed restoring the area to a salt marsh and named it the Fens after marshes in England. He designed an ingenious system of floodgates to control the water level and a concealed conduit system to remove the sewage.

The Fens we see today bear the marks of a number of changes made after Olmsted finished his work. The hulking 1960s-vintage Charlesgate overpass, necessary from a city planning point of view, has broken the visual connection to the Charles River and hidden part of the Fens from the road. With the damming of the Charles in 1910 (near the Museum of Science), the Fens became a brackish marsh clogged with invasive phragmites reeds. Landscape architect Arthur Shurcliff added the Kelleher Rose Garden across from the Museum of Fine Arts in 1930. Victory Gardens were planted in 1941 and remain the oldest still in use in the country.

The Muddy River Improvements, though adjacent to the Back Bay Fens, were the last section of the Emerald Necklace to be completed, because the necessary land taking had to be coordinated with neighboring Brookline. In 1881 Olmsted began the work of converting the brackish Muddy River into a winding stream lined with scenic plantings, creating the section of the Necklace now known as the Riverway.

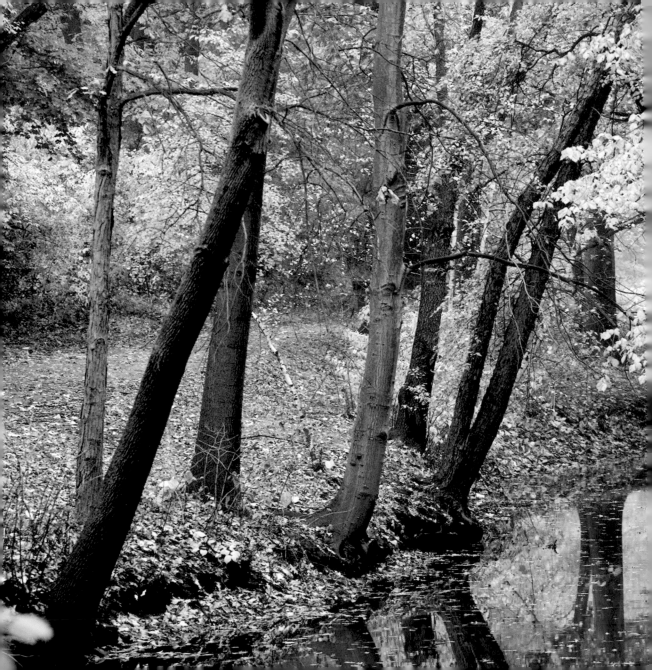

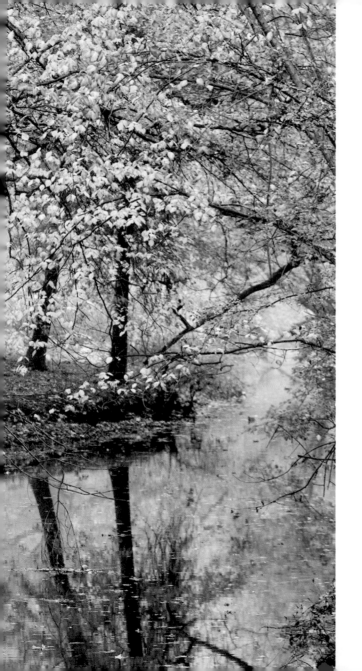

A NOBLER WANT OF MAN IS
served by nature, namely,
the love of Beauty.

—Ralph Waldo Emerson,
 from "Nature," 1836

Muddy River in autumn

Victory Gardens and the Special Needs Garden, the Fenway

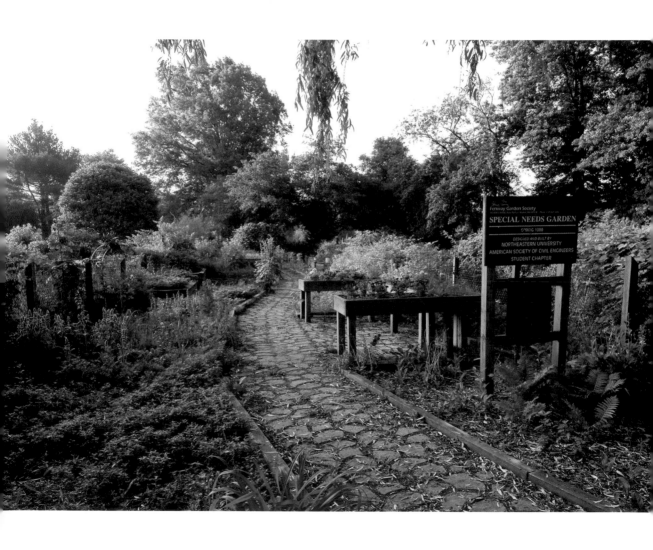

WE WANT A GROUND TO WHICH PEOPLE MAY EASILY GO
when the day's work is done, and where they may stroll for
an hour, seeing, hearing, and feeling nothing of the bustle
and jar of the streets, where they shall in effect, find the
city put far away from them.

— Frederick Law Olmsted, 1870

Back Bay Fens

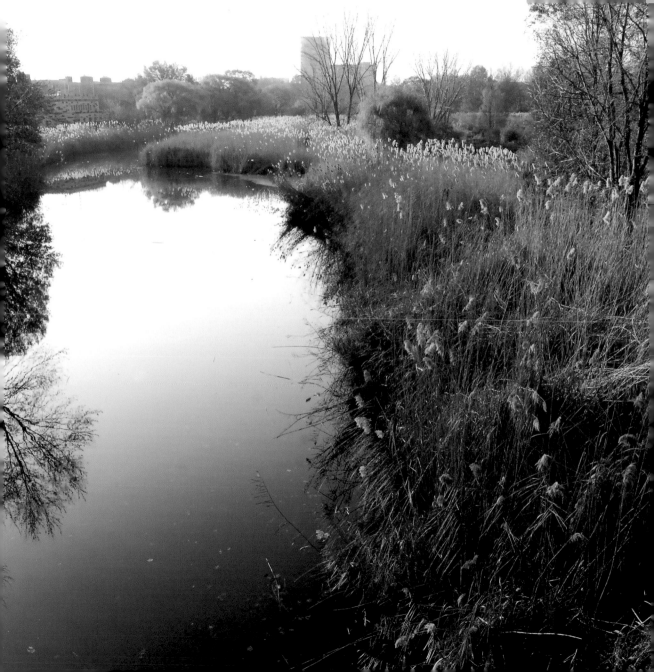

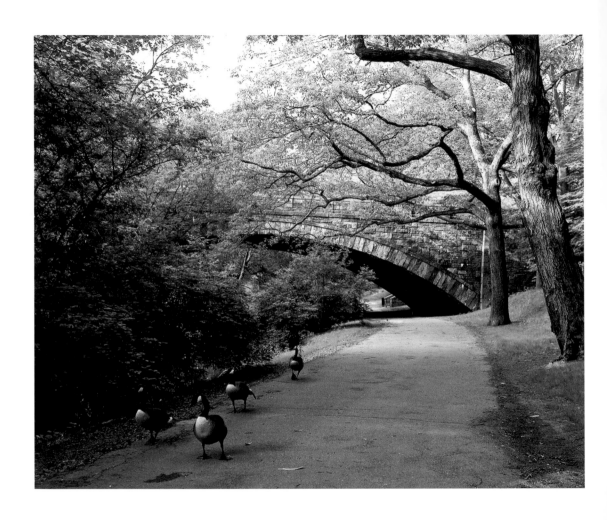

A family of Canada geese stroll in the Fens

The pedestrian and bike path along the Riverway

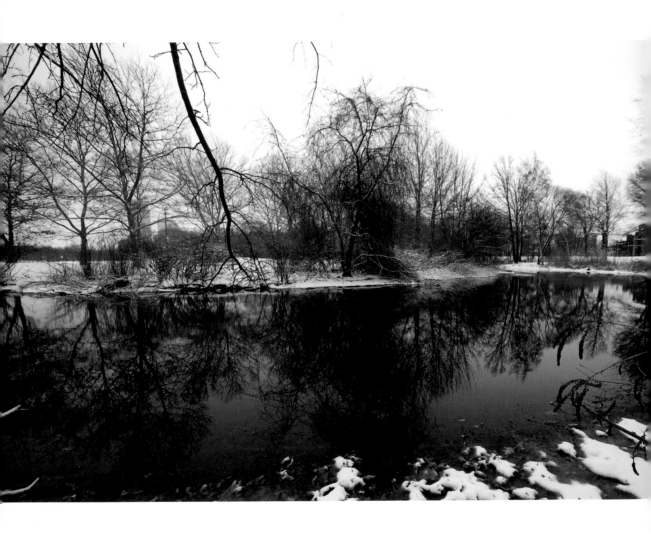

. . .THE BEAUTY OF THE PARK SHOULD BE. . .
the beauty of the fields, the meadow, the prairie, of
the green pastures, and the still waters. What we
want to gain is tranquility and rest to the mind.

—Frederick Law Olmsted, 1870

Fens in winter

. . . THEREFORE AM I STILL

A lover of the meadows and the woods,

And mountains, and of all that we behold

From this green earth; of all the mighty world

Of eye and ear, . . .

—William Wordsworth,

"Lines completed a few miles above Tintern Abbey," 1798

(*overleaf*) The dock at Jamaica Pond boathouse

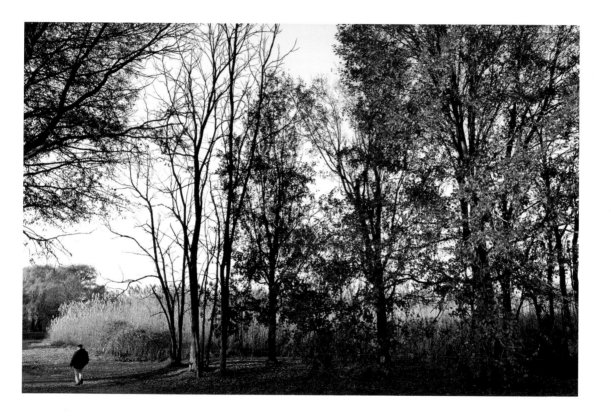

Autumnal splendor, the Fens

Beyond the Riverway, the Emerald Necklace continues south through Olmsted Park, renamed to honor the designer in 1900 after his retirement. Here again, Olmsted managed to remove the visitor from the city, hiding nearby roadways from view and taking advantage of the area's natural features. The small Babbling Brook feeds Leverett, Willow, and Ward's Ponds; a nearby glacial drumlin is surrounded by old-growth woodlands.

Further along the chain is Jamaica Pond, America's first drinking water reservoir. Between the late eighteenth century (when the well on the Common finally proved insufficient) and 1848, water from Jamaica Pond traveled to the city through pipes made from tree trunks. The city's growth forced the opening of a larger reservoir further west, and Jamaica Pond became a popular swimming,

fishing, and skating area. Entrepreneurs moved to harvest the pond's ice, a valuable commodity with countless uses from preserving food to chilling the new drinks popular among Boston's fashionable set. By the 1870s, however, ice operations were contaminating the water and blighting the landscape around the pond. The city acquired the necessary land by eminent domain. Except for taking down the ice houses and several summer homes, Olmsted found little to improve in the countryside around this deep glacial kettle hole pond. In 1910 a boathouse and bandstand were built on the shore.

Jamaica Pond today is a haven for wildlife, especially for many species of birds; each year the pond is stocked with trout, pickerel, bass, hornpout, salmon, and perch so families may fish here.

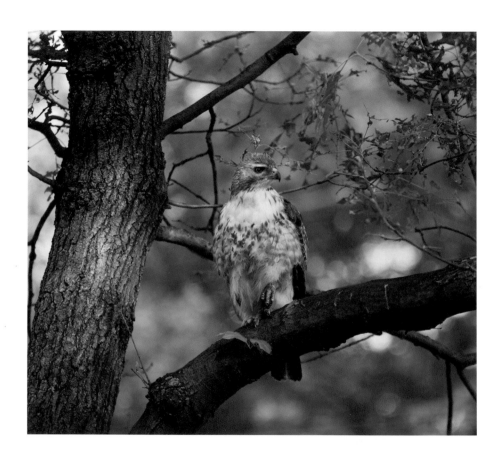

Jamaica Pond wildlife

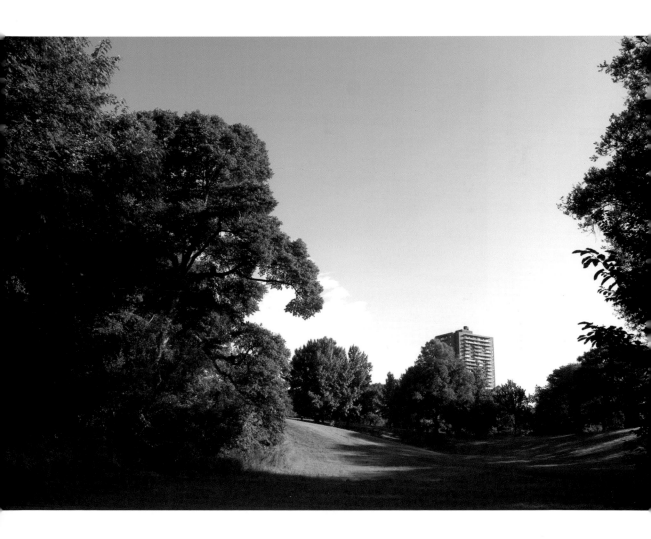

The meadow at Jamaica Pond

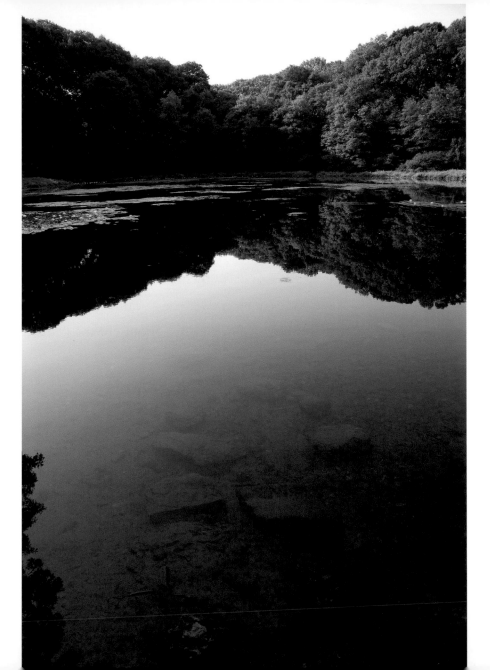

THE PARK SHOULD, AS FAR AS POSSIBLE, complement the town. Openness is the one thing you cannot get in buildings. Picturesqueness you can get. Let your buildings be as picturesque as your artists can make them. This is the beauty of a town. Consequently, the beauty of the park should be the other. It should be the beauty of the fields, the meadow, the prairie, of the green pastures, and the still waters. What we want to gain is tranquility and rest to the mind.

—Frederick Law Olmsted, 1870

Ward's Pond, Olmsted Park

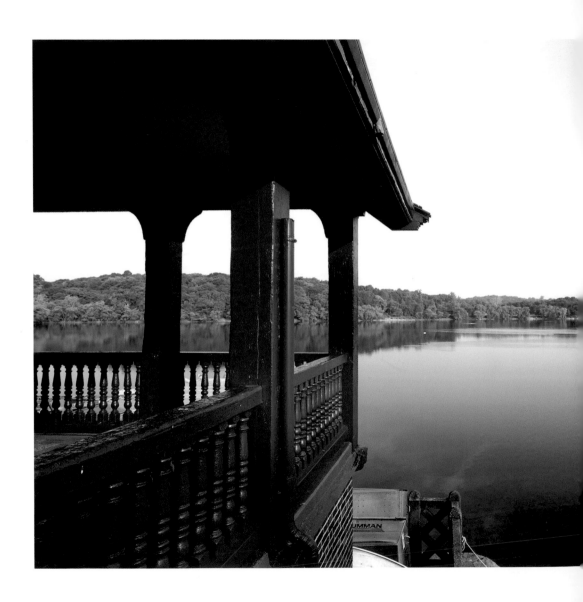

JAMAICA POND—A NATURAL SHEET OF WATER, with quiet graceful shores…shaded by a fine natural forest-growth to be brought out overhangingly, darkening the water's edge and favoring great beauty in reflections and flickering half-lights.

— Frederick Law Olmsted, 1881

Jamaica Pond boathouse in the early morning

...SPACIOUSNESS

is of the essence of a park.

— Frederick Law Olmsted, 1886

Gateway to the Jamaica Pond dock and boats

...HERE THE ARTISAN, DEAFENED
with noise of tongues and engines,
may come to listen awhile to the
delicious sounds of rural life...

—Elizabeth Gaskell (Mrs. Gaskell),
 Mary Barton, 1848

Jamaica Pond in summer

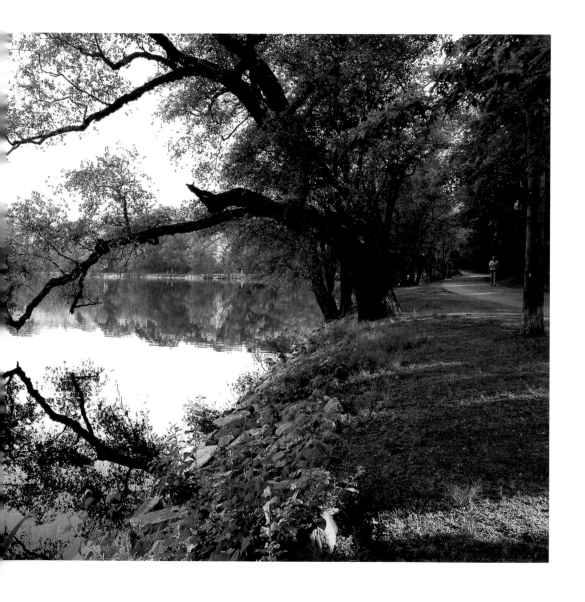

CITY DWELLERS NEED CONTACT WITH
the natural world in order to preserve
not only their physical health but also
their mental tranquility.

— Frederick Law Olmsted

Old tree in Jamaica Pond park

The 265-acre Arnold Arboretum is in many ways the unlikeliest link in the Emerald Necklace. In 1842, Benjamin Bussey, a gentleman farmer, bequeathed part of his large farm in West Roxbury to Harvard University. The enterprising horticulturalist Charles Sprague Sargent (the Arboretum's first director) turned to Olmsted for help. He wanted to combine the farm with the bequest of James Arnold of New Bedford, who had left $100,000 "for the promotion of Agricultural or Horticultural improvements, of other Philosophical or Philanthropic purposes" to create an arboretum. Sargent's idea was to make the Arboretum part of Boston's park system with the city footing the bill for construction and Harvard paying for the plant collections and staff.

At first Boston, Harvard, and Olmsted all resisted the plan. The city and the university were wary of working with one another. Eventually, a deal was worked out whereby the city of Boston would own and police the land and Harvard

would lease it from the city at a cost of one dollar a year for one thousand years in exchange for allowing free public access. For his part, Olmsted knew it would be difficult to combine the recreational purpose of a park with the didactic purpose of an arboretum in a single design. Over time, however, Olmsted warmed to the idea. Taking advantage of the farm's stands of old trees and natural land formations, he and Sargent worked together to design a naturalistic setting that presents tree collections grouped in logical order by family and genus.

Today, visitors to the Arnold Arboretum can see over 4,000 varieties of woody plants and some 14,000 trees, shrubs, and vines. Peter's Hill, the highest point in the Necklace, provides a view of Boston's skyline.

IN THE PRESENCE OF NATURE, A WILD DELIGHT
runs through the man, in spite of real sorrows.
Nature says,—he is my creature, and maugre all
his impertinent griefs, he shall be glad with me.

—Ralph Waldo Emerson, from "Nature," 1836

(*overleaf*) Bikers on Meadow Road,
Arnold Arboretum

Dawn redwoods, Arnold Arboretum

WHAT ARTIST, SO NOBLE. . . AS HE,

who with far-reaching conception of beauty

and designing power, sketches the outline,

writes the colours, and directs the shadows of a

picture so great that Nature shall be employed

upon it for generations.

— Frederick Law Olmsted, 1852

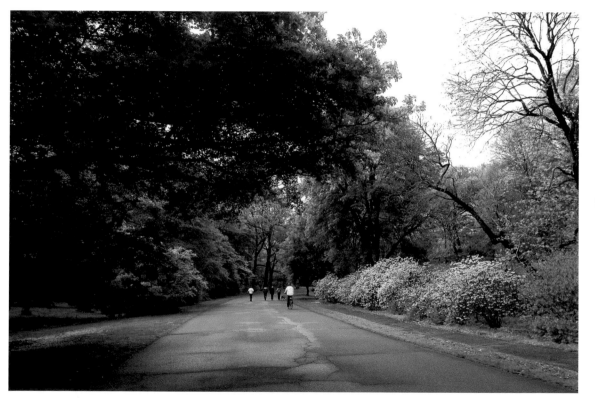

Azaleas, Arnold Arboretum

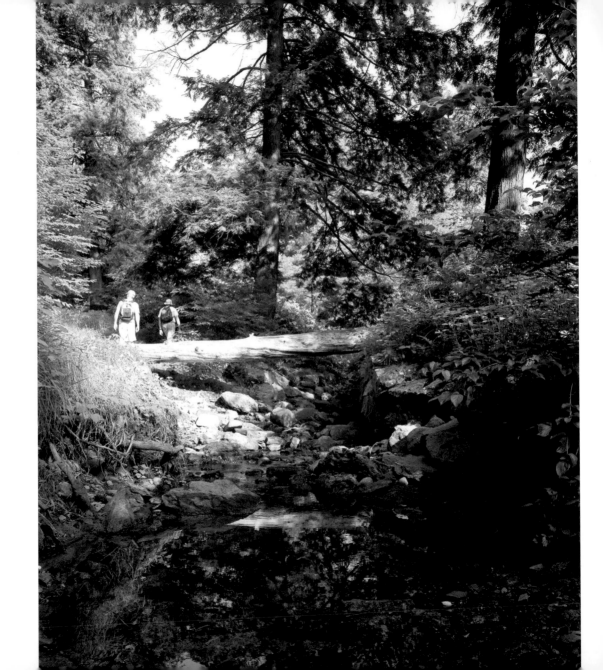

ONE IMPULSE FROM A VERNAL WOOD

May teach you more of man,

Of moral evil and of good,

Than all the sages can.

—William Wordsworth,
 from "The Tables Turned," 1798

Walking towards Hemlock Hill, Arnold Arboretum

WHILE WITH AN EYE MADE QUIET BY THE POWER

Of Harmony, and the deep power of joy,

We see into the life of things.

—William Wordsworth,

 "Lines completed a few miles above Tintern Abbey," 1798

Along Bussey Hill Road

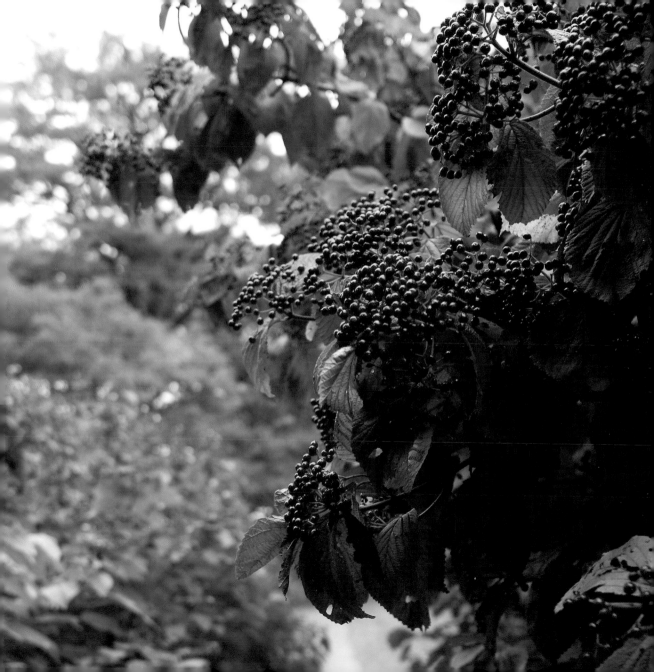

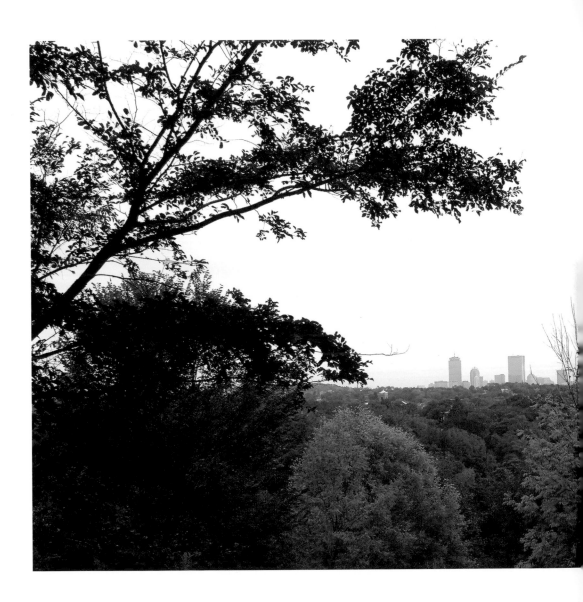

The view from Bussey Hill

At 527 acres, Franklin Park is the largest park within the system, situated in a part of the city that had been farmland within the memories of many Bostonians at the time it was built. Olmsted planned it as the most rural of all the parks, a reminder of a simpler life and time.

The park was named for Boston native Benjamin Franklin, partly in hopes of attracting funding from Franklin's estate, which had been left in trust for the city. A souring economy turned those hopes aside and delayed work on the park until 1885.

Olmsted's design for Franklin Park featured great expanses of rural scenery and woods as well as miles of pedestrian paths, bridle paths, and roadways. One area, called the "Country Meadow," featured a large field with grazing sheep. The plans called for a half-mile promenade called the "Greeting" (never built), a "Playstead" for youth sports, a large tree-filled "Wilderness," spaces for concerts and children's play, a deer herd, and a small informal zoological garden. Here Olmsted could realize his democratic dream of all classes enjoying parklands together, whether

tromping through the old forest or gazing out on the Blue Hills from Schoolmaster Hill (named in honor of Ralph Waldo Emerson, who had lived there in the mid-1820s).

Almost as soon as the Park was completed, informal golf games took over a large section of the Country Meadow. The seldom-visited sheep meadow was eventually converted into the eighteen-hole William J. Devine golf course, second-oldest public course in the country. The Franklin Park Zoo was added in 1911.

Olmsted's final additions were parks at the South Boston beaches and Castle Island, connected to Franklin Park by Columbia Road. But by the time the city got around to that part of the plan, Columbia Road had been commercialized and strung with telephone poles and electric wiring. It lacked the gracious trees that would define it as a parkway connecting those final pieces of the Necklace. And so the Emerald Necklace effectively ends at its finest gem, Franklin Park, where Bostonians still put the city far behind them in the woods and meadows Olmsted laid out for them.

WE WANT DEPTH OF WOOD ENOUGH ABOUT IT

not only for comfort in hot weather, but to completely

shut out the city from our landscapes.

—Frederick Law Olmsted, 1870

(*overleaf*) Franklin Park

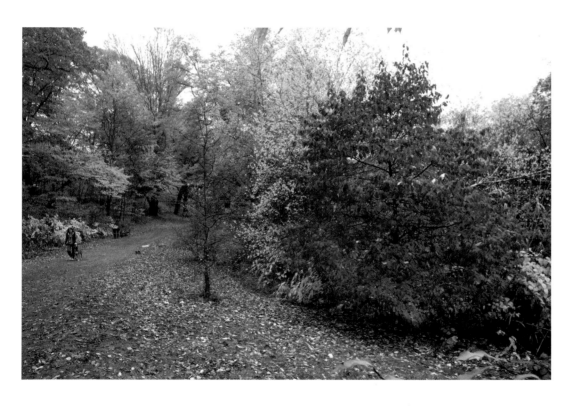

Fall in Olmsted Park

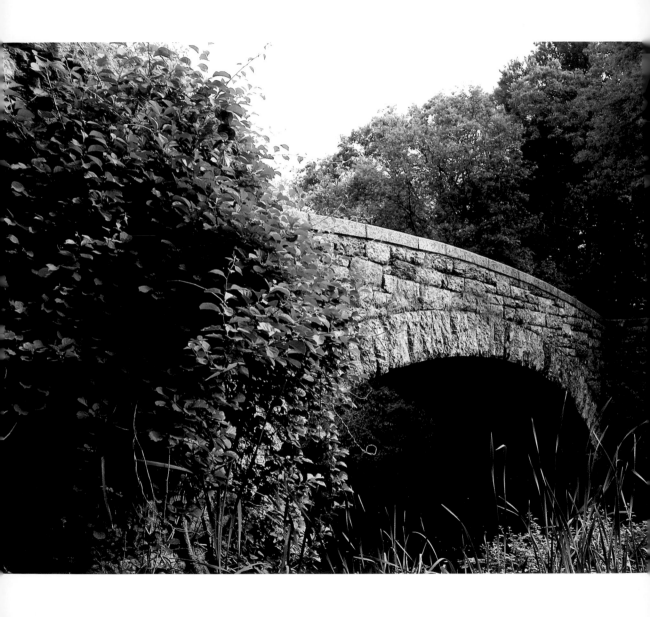

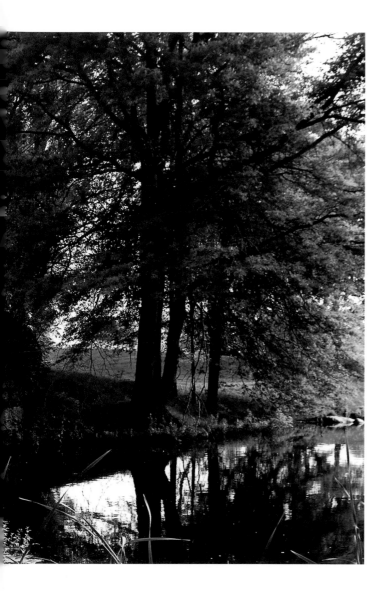

. . . IT WILL BE FOUND
to be, in the artistic sense
of the word, natural, and
possibly to suggest a
modest poetic sentiment
more grateful to town-
weary minds than an
elaborate and elegant
garden-like work would
have yielded.

— Frederick Law Olmsted,
 Back Bay Fens, 1880

Bridge at the William J. Devine
Golf Course

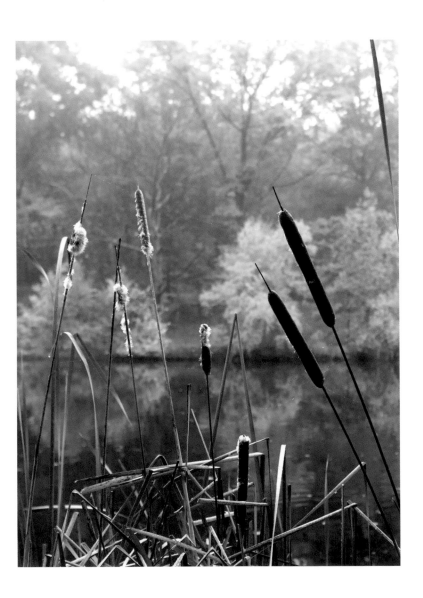

Scarboro Pond,
Franklin Park

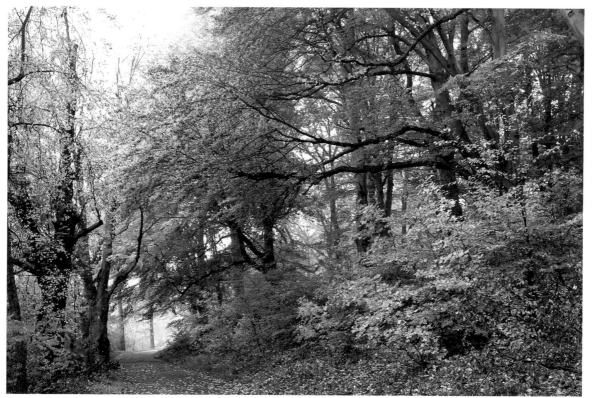

Foliage on Scarboro Hill

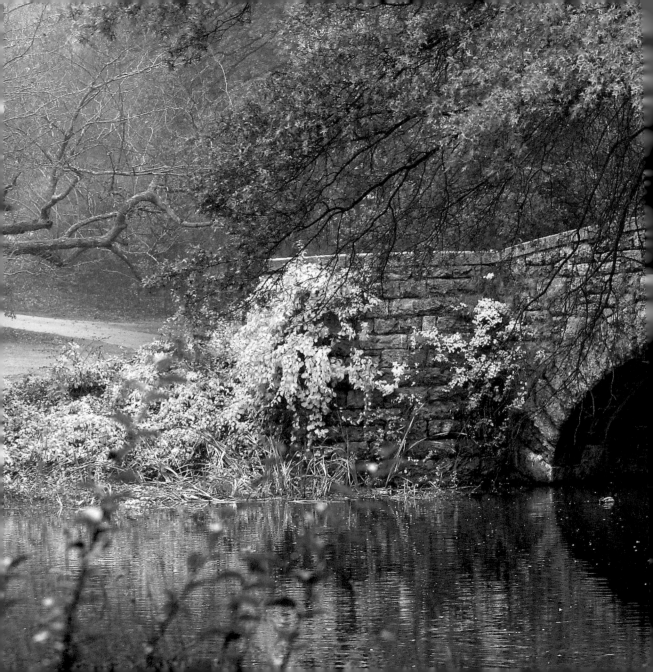

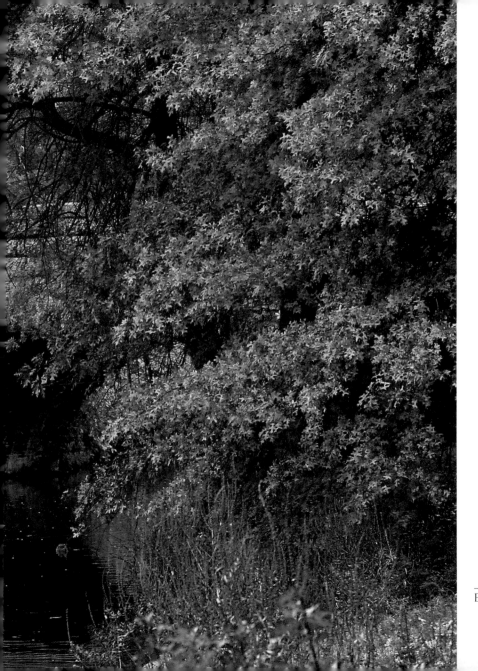

Early morning fog

LET IT NOT BE FOR PRESENT
delight, not for present use
alone; let it be such work as
our descendants will thank us
for, and. . . say "See! This our
fathers did for us."

—John Ruskin, *The Seven
Lamps of Architecture*, 1849,
quoted by Olmsted in *Notes
on the Plan of Franklin Park*

Snow on Olmsted's "Country Park,"
now the William J. Devine Golf
Course

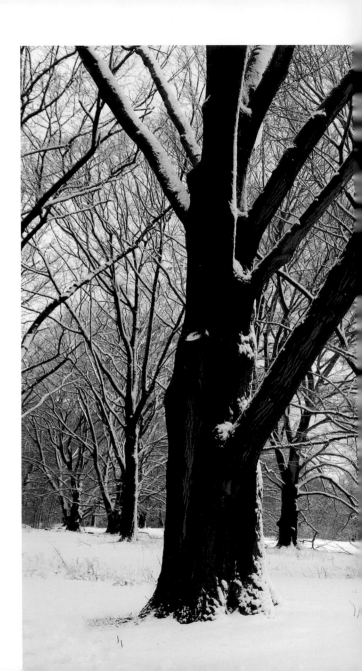

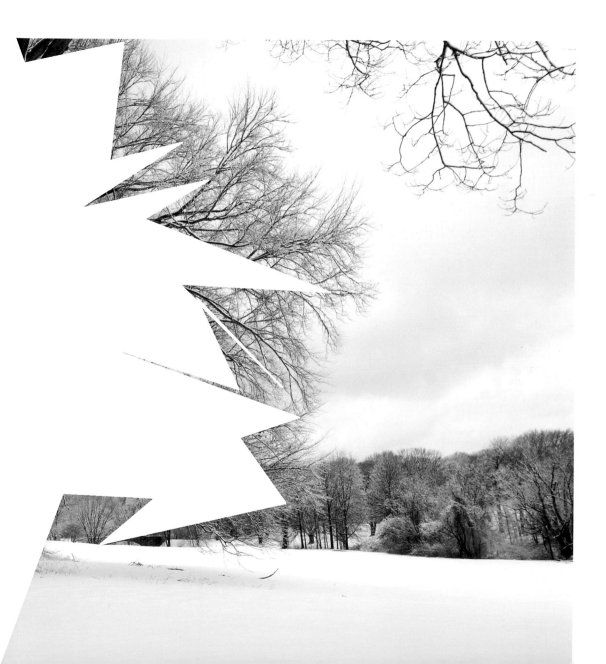

ACKNOWLEDGMENTS

When all is said and done, a project of this scope doesn't happen without the help and enthusiasm of many, many people. I especially want to thank my teenage children Jared and Caitie, and their mom, Anne Marie, for providing endless support and encouragement.

Thanks to Eric Alexander, a photographer and friend, who initially pushed me along and helped draft the original proposal; to Mary Green who edits my written material; and special thanks to Tony DiIanni, who gave me a homemade light box when I was 13, igniting my passion for photography.

I would also like to thank all the people who kept me company, through early-morning photo shoots, trying to get the perfect shot in just the right light. Sincere thanks to my students, whose fresh perspective and determination continues to inspire.

Many thanks to Commonwealth Editions publisher Webster Bull, and writer and editor Perry McIntosh. I am grateful for sales and marketing expertise from Katie Bull, Jill Christiansen, and Diana McCloy.

Finally, eternal thanks to my parents, whose generosity of spirit and integrity encouraged me to begin developing my artistic vision at an early age.

Photograph by Eric Alexander

DAN TOBYNE is a senior program coordinator for housing development for the Commonwealth of Massachusetts. He is also the department's ad-hoc photographer.

A native New Englander, he has been involved in photography for over forty years, since he received his first camera, a Kodak Brownie Savage, at the age of nine. By the age of 13 he had his own darkroom. Early in his career as a teacher of at-risk youth he helped develop a wilderness experiential education program that used photography as a behavior modification tool.

Dan resides on the North Shore of Boston. He is an artist member of the Marblehead Arts Association and a member of the Griffin Museum in Winchester, Massachusetts. His work is on display in public and private collections throughout New England. Dan's photos of the Emerald Necklace are also available as limited edition prints. He can be contacted at laylaenterprises.com.

PERRY MCINTOSH is a freelance writer and editor living on Boston's North Shore.

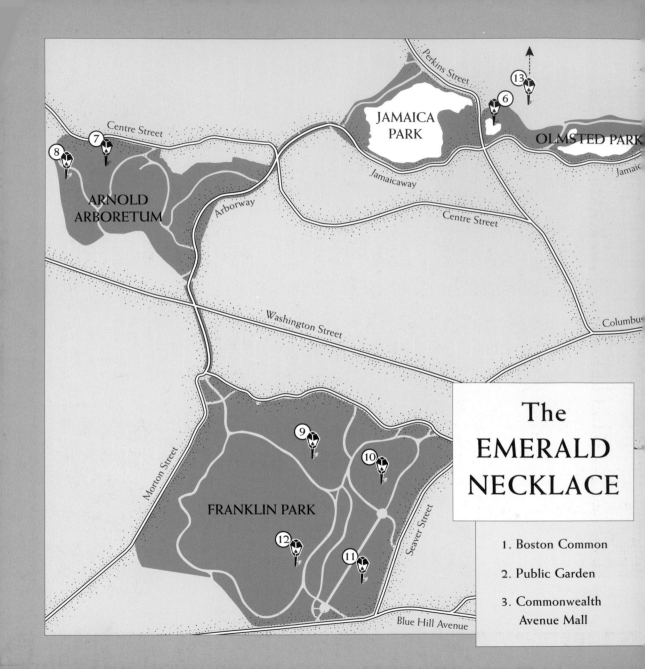

The
EMERALD
NECKLACE

1. Boston Common

2. Public Garden

3. Commonwealth
 Avenue Mall